I0494745

The Urge Overtakes Me and I Must Write

Shelia Lirette

ISBN: 1536813478
ISBN-13: 978-1536813470

DEDICATION

THIS BOOK IS DEDICATED TO ALL THOSE
WHO FEEL THE NEED TO WRITE THEIR
THOUGHTS, THEIR EMOTIONS, THEIR LIFE.
ENJOY AND WRITE ON,
MY FRIEND.

With the New Day Comes New Strength
and New Thoughts. Eleanor Roosevelt

Don't walk in front of me!
I may not follow. Albert Camus

Problems are Not Stop Signs,
They are Guidelines. Robert H. Schuller

I Am So Clever That Sometimes I Don't Understand
a Single Word of What I Am Saying. - Oscar Wilde

Accept the challenges so
that you can feel the exhilaration
of victory. George S. Patton

 Doodle Your Dreams

Outside of a Dog, a Book is Man's Best Friend.
Inside of a Dog It's Too Dark to Read. - Groucho Marx

Live Well! Take Time to Enjoy Life!

Keep smiling, because life's
a beautiful thing and there's so
much to smile about. Marilyn Monroe

You may say I'm a dreamer, but I'm not the only one.
I hope someday you'll join us.
And the world will live as one. John Lennon

 Doodly Doodly Dum

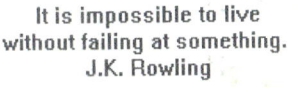

It is impossible to live
without failing at something.
J.K. Rowling

Imagination Encircles the World.
Albert Einstein

It's Okay to Have a
Good Day - Really! Unknown

Don't watch the clock;
do what it does. Keep going.
Sam Levenson

Everything Has Its Beauty,
But Not Everyone Sees It. - Andy Warhol

To be yourself in a world that is
constantly trying to make you something
else is the greatest accomplishment. Ralph Waldo Emerson

Some people never go
crazy. What truly horrible lives
they must lead. Charles Bukowski

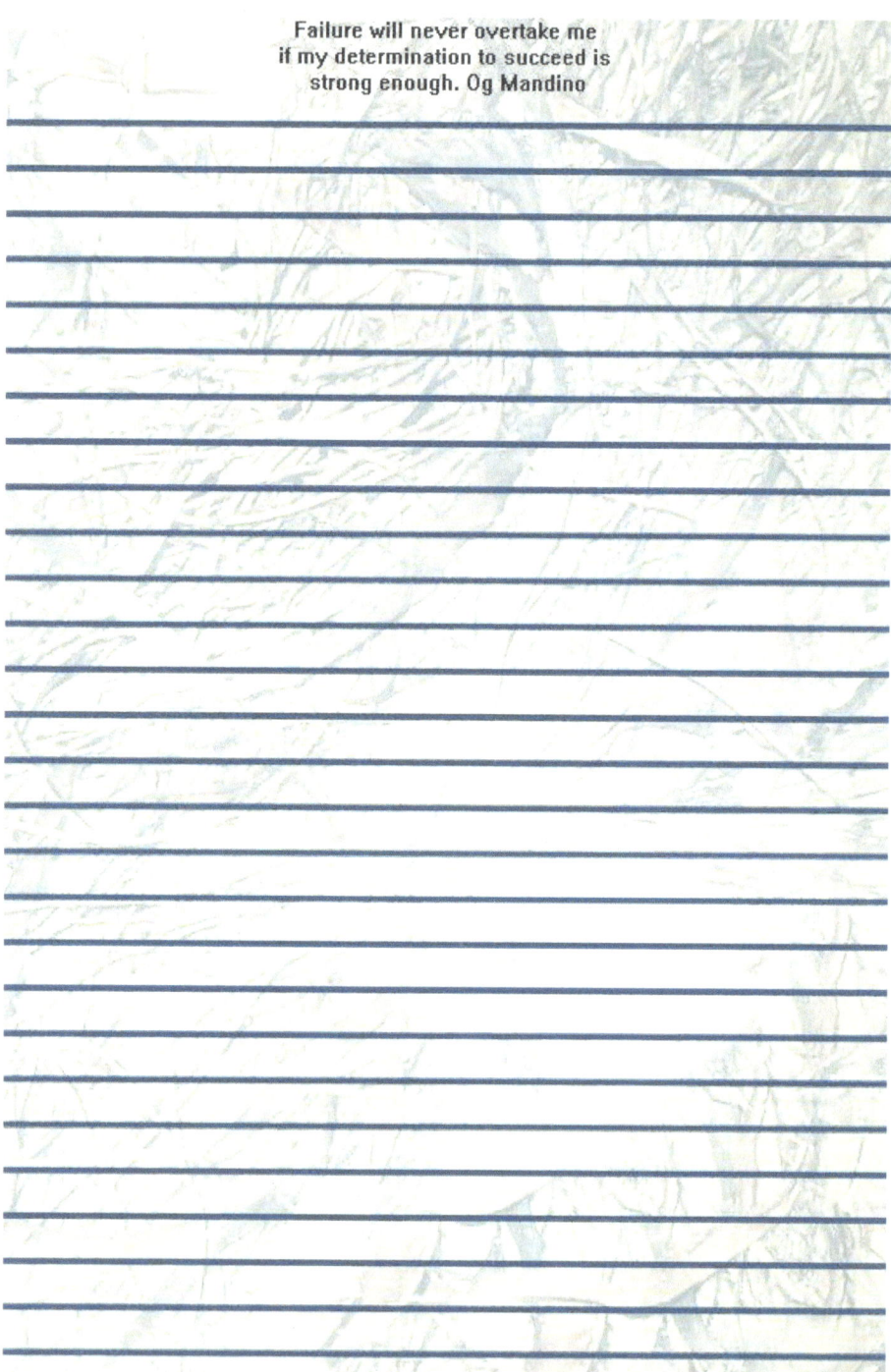

Failure will never overtake me
if my determination to succeed is
strong enough. Og Mandino

Sing like there's nobody listening
William W. Purkey

Draw Your Dreams

Love looks not with
the eyes, but with the mind,
And therefore is winged Cupid
painted blind. William Shakespeare

You only live once,
but if you do it right,
once is enough. Mae West

The Secret of Getting Ahead
is Getting Started. Mark Twain

Anyone Who Has Never Made a Mistake has Never
Tried Anything New. Albert Einstein

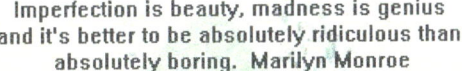

Imperfection is beauty, madness is genius
and it's better to be absolutely ridiculous than
absolutely boring. Marilyn Monroe

All that is gold does not glitter,
Not all those who wander are lost
J.R.R. Tolkien

The truth is, everyone
is going to hurt you. You
just got to find the ones
worth suffering for. Bob Marley

I Begin With An Idea and Then It
Becomes Something Else. - Pablo Picasso

Failure Will Never Overtake Me If My Determination
to Succeed is Strong Enough. Og Mandino

Twenty years from now you will be more
disappointed by the things that you didn't do
than by the ones you did do. H. Jackson Brown Jr.

The Way to Get Started is to Quit
Talking and Begin Doing. Walt Disney

Don't Be Afraid to Dream!

Start Where You Are. Use What You Have.
Do What You Can. Arthur Ashe

You know you're in love when
you can't fall asleep because reality
is finally better than your dreams. Dr. Seuss

When one door of happiness
closes, another opens; but often
we look so long at the closed door
that we do not see the one which has
been opened for us. Helen Keller

You know you're in love when
you can't fall asleep because reality
is finally better than your dreams. Dr. Seuss

**Stop building other's
dreams, start building
yours right now. John Rampton**

Doodle Time

Catch the trade winds in your sails.
Explore. Dream. Discover.
H. Jackson Brown Jr.

You are never too old to
set another goal or to dream
a new dream. C. S. Lewis

Who are you to judge the life I live?
I know I'm not perfect and I don't
live to be but before you start pointing fingers
... make sure you hands are clean! Bob Marley

Today you are You,
that is truer than true.
Dr. Seuss

 Awesomeness!

I'm not afraid of death;
I just don't want to be there
when it happens. Woody Allen

This life is what you make it.
No matter what, you're going to
mess up sometimes, it's a universal
truth. Marilyn Monroe

Throw off the bowlines. Sail away from
the safe harbor. Catch the trade winds in
your sails. H. Jackson Brown Jr.

Don´t walk behind me! I may not lead.
Albert Camus

Always, Always Believe in Yourself,
Because if You Don't,
Then Who Will, Sweetie - Marilyn Monroe

Good, better, best.
Never let it rest. 'Til your
good is better and your better
is best. St. Jerome

 Doodle Dreaming

It Is Never Too Late To Be What
You Might Have Been. - George Eliot

With the New Day Comes New Strength
and New Thoughts. Eleanor Roosevelt

**The way to get started
is to quit talking and begin
doing. Walt Disney**

With the New Day Comes New Strength
and New Thoughts. Eleanor Roosevelt

In order to succeed,
we must first believe that
we can. Nikos Kazantzakis

Walk beside me! just be my friend.
Albert Camus

I am good, but not an angel.
I do sin, but I am not the devil. I
am just a small girl in a big world trying
to find someone to love. Marilyn Monroe

**Keep your face to the
sunshine and you cannot
see a shadow. Helen Keller**

 Doodle On

One good thing about
music,when it hits you,
you feel no pain. Bob Marley

Always do your best. What you plant now,
you will harvest later. Og Mandino

Sometimes good things fall apart
so better things can fall together. Marilyn Monroe

The only way out of
the labyrinth of suffering
is to forgive. John Green

Don't walk in front of me!
I may not follow. Albert Camus

Outside of a Dog, a Book is Man's Best Friend.
Inside of a Dog It's Too Dark to Read. - Groucho Marx

I am enough of an artist to draw
freely upon my imagination. Imagination
is more important than knowledge. Knowledge
is limited. Imagination encircles
the world. Albert Einstein

Keep Your Eyes on the Stars, and Your
Feet on the Ground. Theodore Roosevelt

Yesterday is history,
tomorrow is a mystery,
today is a gift of God,
which is why we call it the present. Bil Keane

It matters not what someone is born,
but what they grow to be. J.K. Rowling

In Three Words I Can Sum Up Everything
I've Learned About Life: It Goes On. - Robert Frost

Dream Big...Set Goals...
Take Action
Unknown

A Creative Man is Motivated by the Desire to Achieve,
Not by the Desire to Beat Others. Ayn Rand

I am a common man with
common thoughts and I've led
a common life. Nicholas Sparks

Draw Your Dreams

There are only two ways to live your
life. One is as though nothing is a miracle.
The other is as though everything is a
miracle. Albert Einstein

I Have Not Failed. I've Just Found
10,000 Ways That Won't Work - Thomas A. Edison

Outside of a Dog, a Book is Man's Best Friend.
Inside of a Dog It's Too Dark to Read. - Groucho Marx

It is better to remain silent at the
risk of being thought a fool, than to
talk and remove all doubt of it. Maurice Switzer

Problems are Not Stop Signs,
They are Guidelines. Robert H. Schuller

ABOUT THE AUTHOR

As a Florida Native, Shelia enjoys all things "beachy" and visits several beaches each year.

In fact, the photographs behind the lines in the journal are pictures she took at Lover's Key Beach which is located around Bonita Beach FL.

She has written over twenty articles, a children's book, An Adventure on Spook Hill, and at least a couple of illustrated journals.

She has been self-employed for over ten years and is an accomplished artist and entrepreneur. She continues to write, create and explore new locations.

www.ingramcontent.com/pod-product-compliance
Lightning Source LLC
Chambersburg PA
CBHW040829180526
45159CB00001B/119